First Harvest

Collected Poems, 2003–2013

MAT KONDO

PARTRIDGE
A Penguin Random House Company

To order additional copies of this book, contact
Toll Free 800 101 2657 (Singapore)
Toll Free 1 800 81 7340 (Malaysia)
orders.singapore@partridgepublishing.com
www.partridgepublishing.com/singapore

This book is dedicated to
the Great Bard of Nature
Gary Snyder.

Thank you for lighting the fuse.

Contents

Acknowledgements...ix

Introduction...xi

The Antidote..1

The Daily Grind..2

Codex of the Cosmos..6

Fits and Starts...8

God vs. the Corporations..13

Ocean at Night *(for Lew Welch)*...15

Rock Mountain Vision *(for Gary Snyder)*............................17

Cells of Sin..18

Calling All Underdogs...20

Dreamtime...21

Idle Musings #1...23

Of Beauty and Struggle...27

A Glimpse of Lost Innocence...28

Angel at My Doorstep..35

Buddha Dawn..37

Disode to Tokyo..39

Living with Radiation *(for the people of Tohoku)*................41

Ward Z *(for William Carlos Williams)*.................................46

Winter Tree .. 48

Oh Savory, Reckless Abandon 50

Deserter *(for Gregory Corso)* ... 52

Modern Stench ... 54

Life Resurging *(An Ode to Jack Kerouac)* 56

Delilah of the Sands *(for Michael McClure)* 59

I Dream of Arson *(for Allen Ginsberg)* 62

Pride ... 64

Diatribe of the Mind ... 67

Paean to Romero .. 74

Spirit Indomitable ... 76

I Will, I Will .. 78

The Big Con ... 82

What Does It All Mean? *(Written after a visit to the Tokyo exhibit of the Book of the Dead)* 84

Acknowledgements

The author would like to thank the following poets, writers, and friends who have been an inspiration and a great source of support over the years. This book would not have been possible without their inspiring poetry. First I must acknowledge my major literary heroes—Jack Kerouac, Gregory Corso, Michael McClure, Lawrence Ferlinghetti, Gary Snyder, Lew Welch, Allen Ginsberg, Ray Bremser, Alfred Lord Tennyson, Percy Bysshe Shelley, William Blake, William Faulkner, John Milton, Federico Garcia Lorca, Bob Dylan, and Townes Van Zandt among others. Thank you all for lighting the fuse.

I would also like to thank Kevin Ring at Beatscene Press for his encouraging words while the manuscript was still in production, as well as a special wink to Hassan and Khalil for being truly great friends over the years. My sincere gratitude also goes out to François Ouellette for a fun and successful photo shoot. François, I am very happy with the rear book shot. Finally, the author would like to say a big thank-you to Owen Wade, my literary brother-in-arms, who was the source of much encouragement during the production process, as well as my deepest gratitude to Julian Filochowski, chair of the Archbishop Romero Trust, for his permission to print a photo of Oscar Romero in this book.

Mat Kondo
Tokyo
May 2013

Introduction

There comes a time in every man's life when he has to choose what to do with his career. And what a terrifying moment it is. At some point in our lives, we are usually presented with two relatively obvious but very different choices we can take. We can decide to walk down the path which leads to dream fulfillment, but we must forsake all else in order to get there. The other well-known and oft-taken path is what I would call the 'safe way out', in which we abandon our dreams and look for a stable and (if possible) well-paying job. When I was nineteen years old, I stumbled upon the idea of 'a third path', in which artists like musicians and poets try to hold down a regular nine-to-five job, while working on their poetry during the sparse moments of free time which they can manage to salvage here and there from amongst all the detritus of their day-to-day lives. What I naively failed to understand and appreciate at this time was the amount of energy and commitment that would be required to perform such an undertaking. Let me tell you, all ye young poets of today, our muse demands *everything* of us and asks only that we remain true to the cause.

Many of the poems I have compiled over the years were first written in a state of mind beyond exhaustion, what you could describe as a type of 'fever', as I stumbled out of the office from lamppost to lamppost or snuck off to the café or men's room to scribble down whatever happened to rain down

onto my skull at any given time of the working day. Just like a marathon runner who finds his second wind after running for many hours, a poet hits a certain stride when he pushes his body and mind to the limit. Something opens up. That's the only way I can describe it. In a way, this is similar to the Rimbaudian idea of overwhelming or deranging the senses. This is when I saw my rawest poetry come to the fore. Just like Ray Bremser, I would also call myself a 'disciple of Jack Kerouac', and following in his footsteps, I try to write down the initial inspiration as spontaneously as possible in the nickel notepads which I carry around in my pockets, ready with pen and paper for when the Dove descends. However, I also believe what Gregory Corso said about poetry—the editing of the poem is the most important part. Receive the transmission and write it down, before it is lost forever. Then fine-tune.

First Harvest is the culmination of ten years' work. Most of the poems herein were written while I was living or staying in various cities throughout Japan—Osaka, Kochi, Tokushima, Yokohama, and Tokyo—either hastily scribbled down during work lunch breaks in coffee shops, in ragged hotel rooms at dawn, while glancing out the window of a speeding commuter train, or sometimes while wandering the streets at dawn for inspiration.

The main reason why I write poetry in the first place is to cut through all the confusing language out there, all the clutter, especially the advertising propaganda and nonsense slogans and mantras that twenty-first century man is being constantly fed. Bob Dylan once said that a poet's job is to inoculate the people with the truth. Poetry has the power to cut through all

the propaganda and bullshit like a machete cutting through thick jungle. As I mention in 'The Antidote', the poem that opens this collection,

> All you have to do is breathe deep,
> polish your eyes,
> and let your mind roam.

ॐ

The Antidote

ॐ

Harbingers of deception,
the word-virus spreads
like rabid carrier pigeons.

But there is an antidote.
Poetry,
betrothed to truth,
can deliver seeds
of great exploding beauty
and illumination.

All you have to do
is breathe deep,
polish your eyes,
and let your mind roam.

The Daily Grind

The daily grind.
The grind of the train wheels as they screech to a halt,
as the door yawns open,
beckoning you to jump on and ride,
shoot you through to the other side,
to work and to a job
that you don't even like,
that you don't even want to go to,
with people you don't have anything in common with.
But you join their ranks.
You force a smile.

Meaningless work, boring-as-hell work,
slowly turning you into a boring-as-hell person.
You're tired of all this drudgery.
Your only hope and light for the day
being the distant, beaming coffee shop oases,
at the end of the line, in your mind,
which jump you with a jolt,
knock you back into slightly-better-than-poor shape
to send you back to your work-office fix.
Braving the elements, not to mention the traffic,

terrified of imposed, artificial schedules and
the mental torpor from cheap burnt coffee and burned-out
 fatigue
swirling and throbbing in your head.

And behold! The great unspoken but omnipresent terror
lodged somewhere back there in people's stagnant, staggering
 minds—
the terror of being out of work, with no roof over your head,
with no bread in your plate—that do re mi
which drives you on and on and on, meaninglessly,
 compellingly,
like a mad midnight coachman,
wildly whipping his ferocious black horses,
baring their pearly white teeth in the jet black of night.
The great unchallenged fear.
The diamonds which we constantly need to dig for,
steal, beg, take, and ultimately die for.
And meanwhile we blindfold our conscience,
suffocate it with blankets of fear and procrastination,
ignoring our secret yearnings but always feeling them burning.
those voices inside all of us screaming out,
Life is not that way; it's over here! It's right here, right now
all around you! It's yours for the taking. Go on; take it now!

But yet still we give our conscience—our true, buried selves—
a shot to put them both back to sleep,
until our financial fixes are temporarily sated
and our fear of not belonging,
being labelled one of the endless stream of society's taboos,
constantly bred up by the machinery of the gatekeepers.

these mad, fickle machinations compel us, drive us,
throw us headlong into the mad, screaming world,
leaving our aspirations to rot in the wings,
turning as rusty and as faded as Grandma's long-forgotten
 kitchen curtains.

But yet, somehow, we constantly need to bleed to
remember what it's like to be healed.
And constantly need to love to
remember what it's like to hate.
And constantly need to suffer to
remember what golden nirvana showers of rest, comfort, and
 reward
await us over yonder,
where the rainbow ends and twinkling rays of rebirth await us all.

But even rest itself is an illusion,
for everything is in a state of flux.
The wheel is forever turning
as we are spun into circles of forever yearning
to scuffle amongst the dirt and mud
for lost crowns and broken jewels
and misplaced thoughts, crumpled hearts, and
cobweb dreams of yesteryear.
Like an old, lonely, forgotten patient
left to scream alone in his death-knell agony,
quaking on hospital beds
like choking fish, frantically beating their tails on the ship's deck,
waiting, screaming for air
to come and rescue them.
Yet no one seems to hear.

Nothing can drown out the cacophony
of the modern heaving, relentless, merciless world,
all wrapped up in its steaming ahead
and bulldozing over relics and fragments
of artistic beauty from ages of glory, now slowly fading,
pushing on in its endless quest for bigger and better machines
and churning out endless armies of
egotistical, vain, self-righteous, incorrigible materialists.

The pathetic ones whose
fires of pride still burn bright in their breasts
look for any way to outshine their brother ants,
shutting off the humbling realization
that we are nothing more than just that—ants—
in this great, wide cosmos.
Stumbling ants down here.
And we've only got slippery ropes of hope
to hold on to, or a pocketful of prayers,
and only one number and one coin in your pocket.
So think carefully
about who you gonna choose
when you make that final call.

Codex of the Cosmos

It began with a spark
struck swift in eternal dark.
Sparks begat fire—
cosmic heat
climbing higher.

Earth was born of Fire,
a burning, blazing, holy pyre.
But yet, in turn, Earth did learn
to smother its mother
and then to tame
its tongues of flame.

Hand in hand
Fire ran
with screaming Air,
its Death-Bride,
true and fair.

And then there was Water,
the gods' own Tear-Daughter,
come to keep the peace between Fire and Earth
and to reflect the stars in their sparkly mirth.
Come to flicker life in all its hues
and to paint the sky a cobalt blue.

When the four houses had slaked their lust,
life then arose in its mysterious thrust.
A new day
then did slowly dawn.
Behold man,
the gods' new pawn!

Fits and Starts

I started out with a quest
to improve my handwriting.
But before I knew it,
one thing led to another,
like some tempestuous affair freshly begun.
It started pouring out of me
in a fever and a fury.

What set it all off like an elaborate trap?
Either I felt like I was being compelled
by some invisible benevolent force,
or I just did it to fill
the intolerable intervals of boredom.
Anyway, let's get on with it.

Trains purring to the new metallic dawn.
The beggar clutching his bowl with toothless grin.
The cries and growls of shiftless bums
in the half-light of morning,
bequeathed the fading jewel sky.

Despair of death far off,
clutched inside the energetic bosoms of golden youths.
Dreary, bleary eyes staring down,
drawn down by some oppressive weight.
Going off to work again.
Too ashamed or confused to look up
at their dream dreams,
ripe and ready for the picking.
Too indoctrinated with custom and politesse
to draw their minds
From out of the damp shade.

I'm no better than them; I'm no better than them,
with our ranting and raving,
cursing and endless procrastinating,
working and holding tongue
out of fear of the power of its leash.

You tremble to look at yourself in the mirror.
Look at yourself in the mirror.
And you raise a broken fist at Hollywood
and curse it for filling you
with false hopes,
for making you believe
and construct your own utopia
with impossible loves and far-fetched principles,
and then curse yourself twice
for allowing yourself to be deceived
once again, yet again
(shaking your head at yourself),
into a greenback folly fever.

But no more.
No more! You silently scream and scowl and seethe.
But alas, Time the opiate soothes,
and memories wither and rot.
And you commit the same mistakes
over and over and over again.

And finally realize
in a moment of delicious truth
that you have stumbled upon
that the only way to press on,
to carry on,
to stumble on,
is to change yourself,
physically rebelling against the programmed atoms
telling you otherwise.
And you do this not out of pride
nor desperation complete,
nor for the sake of change,
but for survival.

The basic primordial need
is coming home to roost.
And then it dawns on you,
the invisible pawn of survival—Death.
The fear of Death.
The silent spider with lightning-forked eyes
hot on our tails,
lurking around corners
and down alleys,
and at our very feet.

And we let it swallow us,
devour us.
Devour us
whole and spat out for breakfast, no bones remaining.
All slaves to the Spectre!
Killer of hopes, killer of dreams,
killer of frustration
and buried loves never pronounced.

Death to the Spectre!
Down with Maya!
Embrace the fear like blowing a kiss at the plague.
Even Death can be killed with a laugh.
Be baptized in the free-flowing fury
of life once again.
See the roaring horses, with manes of white foam,
leading the charge of the angry river.

Rise to the bait.
Triumph and stomp around proudly.
Kiss passionately.
Work enragingly.
Caress endearingly.
Fuck tenderly and with honesty.
And walk right on out
into the spilled ink of the night
as grey Cadillacs push on
under a black vault which towers
above us all.
And above all we will ever know,
studded with diamond star cuffs,

as the fog sloughs off its gown and veil
for another shade of gloom.
Lo! In the distance,
the sound of the city's dark, coughing heart.
Boom! Boom! Boom! Boom!

And silently weep for fellow man,
struggling, with his mind
pulling him in two directions.
His conscience silently prodding
and whipping and branding him.
His family reminding him of his duties
and responsibilities
'till his death-do-us-part unwanted blood fealty.
His job slowly killing him.
His dreams slowly fading,
like abandoned snaps locked up
in cobwebbed darkrooms.
His loves slowly going sour.
Pray for this man!
Pray for him!
Not because I ask you,
not because you must,
but because there is still hope
as long as the soul is willing to listen,
as long as the embers have yet to fade.

God vs. the Corporations

Oh bringer of woes
and seeker of solace,
how many heartfelt prayers and
sincere reflections should we offer up?
How many votives should we light
so as to waylay your wanton destruction?

Any indication of whenst you'll be stopping by?
But aren't you already here,
among us,
with your million sets of eyes?
Just Heaven's got your tongue,
and Earth's got your ear.

C'mon, speak up!
Show yourself!
If only I could guarantee
that everyone would agree
with me
in saying,
We promise not to crucify you this time.

But I wish you good luck,
telling the pot-bellied purse pigs,
Give your goods to the poor.
Fire and brimstone and famine on Earth.
But I'm sure you know what's in store,
for every man cursed
rises another to prove his very worth.

Just tell us where to toss our sins,
where to strip our profits,
where to sit and beseech in the choirs of Man,
and who to raise the coffins.
What to clutch to, and what to forsake,
what we can salvage, and what we can take.
How can we identify you,
and how do we know
we haven't been led along
for all that we sow.

Why must our homes be destroyed?
And why must my friends be busted
just for being skeptical and cynical
about being fashionably enlisted?

Ocean at Night

(for Lew Welch)

Dark silhouette mountain
with crystal shards in its crown
stands perfectly still
over the bay
Deep / Majestic /
Stoic / Brooding /

Over a sea
of sinister jade jelly
with crest-caps sparkling
in the black sand
of night air.

And the moon—
ah! the moon,
occupying the sun's throne of night—
shines down
its splintered message
onto lovers
wrapped up in trysts,
onto logdam beavers

swimming backstroke,
on to workers
sweating in midnight shifts,
and on to the ocean's
restless heart,
which builds and topples
an army
of seawater fists
and frothy crags.

But to the screaming eagle kings
and their seagull queens,
the ocean
is a flowing carpet
laughing like
fish scales.

Rock Mountain Vision

(for Gary Snyder)

The smell of lightning,
imminent,
ready to strike in the mind—
ripples of satori
crackle on streams of air.
Pebbles look sharp
in their snug riverbeds.

Pine boughs creak.
The wind flows through treetops
sounding . . . distant . . . rain.

A thrush stops mid-song
and smiles.

Cells of Sin

The devoted scientist
bends low
over his scholarly lamp,
looking, probing, searching
with frenzied eye
deep into the bone of Cain
that shackles us all,
leaving no marrow unturned,
seeking desperately
for the long-lost cells of sin.

Then one day he shouts,
Eureka! I've got you!
Now if I could just
isolate you
and remove you
from the collective gene pool of human existence,
then I would have performed
the greatest human act
under the searing sky
since the Fall and the Flood.

He howls 'neath a blood-sickle moon
with victorious Dr. Sax laughter.
Now it's time for the Grand Release—
No more guilt!
No more dunkings in Lamb's Blood!
No more cavalry sorties
by the Son
sent out to do a father's deed.

Jesus, hang up your hat, man.
We're coming home.
The scientist breaks out into song—
Swing low, sweet chariot,
they're coming for to take me away—
(Men in white jackets approach with straitjacket)
I'll pack up my bed and follow
if you'll just
lay me
a golden pallet
down upon Heaven's floor . . .

Calling All Underdogs

Attention!
Calling all underdogs,
callings all underdogs.
Report to your bodhisattva superiors immediately!
And get thee hence
and carve out your own
special slice of
Nirvana manna
from Buddha's
giant compassionate heart,
which booms like a kick-drum death-knell gong
across the moors of the cosmos.

Dreamtime

Fish at the bottom of the deepest ocean
dreamed it had wings to fly
up, up, and above
the murky film-water clouds
that bobbed up and down at the ceiling of his imagination.

The lion lazing in the savannah
by the sea,
gazing up at the swirling skies
wished he could grow wings
to waltz among the eagles
and, dreaming of holy prey
that lurked within the clouds,
a drop of saliva
fully formed from his ruminations
fell slowly
from his
King of the Jungle
fangs of murder.

The worker ant
scurried around
dodging raindrop water bombs
crashing fresh out of heaven
and wishing to grow enormous legs,
legs that could outrun
the thunderous grassland giants.

Idle Musings #1

We are born, we race through life, then we die
with soil clutched between our fingernails.
Some play their cards, lay down their bets;
others just bide their time waiting for a sign
or decide to fold.

I played it safe for the first third of my life,
making endless investments,
investing in my credentials through study,
investing in my free time by partying,
making and breaking continual backup plans,
but then the golden ball fell on my side of the court.
No more stalling, no more going back.
Deep in my chest, the locomotive need
to understand and stop playing around with life
began to roar.

When the time comes, you've got to let it all go.
Comfort is a trap.
It devilishly whispers to you
like a siren licking your ear
with forked tongue.
It's all right; rest, rest awhile.
Cast your worries onto tomorrow.

But the most dangerous trap of all is habit,
the habit of going through the same boring bullshit tedium
 every day,
day in, day out, day in, day out.
Get a job but DON'T LET IT GET YOU!
Because once it does it won't stop till you are through.
You run this rig; you steer this ship.
You have to let them know this—constantly.
Money is a necessity of life just like food.
If Satan is the Prince of Air and of this world,
then we are all his fleeting whores
dancing to the same dazzling waltz
at various points throughout our lives.
It's what you do with your FREE TIME that counts.

That's how people should be judged,
not on the basis of some job or some six-digit figure salary
or some brand of clothes covering your glassy flesh,
but on how you spend your time on shaping
those hidden beautiful thoughts
unique to you

and slowly uncovering all the secrets of your self
that you choose to place naked at the door of the world.

Be sincere and be true to you.
The worst thing in the world is to be labeled a fake.
Don't sell out to *their* cause, fight for *yours*,
and you'll know all your true friends
because they'll be rooting for you too.

The best we can hope for and strive for in this life
is that we will live up to our ideals and dreams
and find out what we are here to do
down here on this testing ground.

We also hope
those whom we hold truly dear
in our cavernous minds and thoughts
will see through all the glitter and dross
to the very golden core of our true being,
which they see pulsing before their eyes,
and that, my friends, is what it's all about.

When your time comes, there's no porter or bellboy.
You can't take anything with you when you go
except your spirit,
which leaves this life like a wreath of air.
If you've got something to say,
lay it down and lay it down quick
with the flurry of a pen, the stroke of a brush,

the voice of a town crier, the pluck of a guitar.
That way, your soul transmogrified into art form,
defiant like liquid gold,
may plant the seeds into some far-off future poet's mind
who will take them like a bird finding a groove on
endless currents of wind
and run, Run, RUN!

So when I render back my clay, which makes up this earthly
 frame,
don't weep. Don't weep unless the flowers on my grave need
 water.

Of Beauty and Struggle

There are many rivers with laughing voices.
There are many angry people setting light to their torches.
There are many woods haunted by restless winds.
There are many people on a pilgrimage of sin.

There are many people crying and dying for love.
There are many names for God up above.

There are many triumphs blasted like a trumpet.
There are many injustices swept up under the carpet.
There are many necklaces with many gems.
There are many hungry mouths and filthy big pens.

Division is winning.
It stings and rips and tears
by sowing greed and destruction
and assailing us with fear.

Nevertheless . . .
there are many souls
waiting to shine like fresh fallen snow
in the hamlet, in the cities, and in the ghetto below.

A Glimpse of Lost Innocence

I'm strolling through golden wheat fields of eternity
under a coal-black sky.
The stars have been pulled down,
tempting—imploring!—mere mortal fools such as I
to clutch for those shifting, restless dreams
that coalesce into white-gold manna
dripped pure out of heaven.
I'm tempted to clutch,
to reach for the impossible,
the unreachable, the unassailable.

The wind grazes my cheek.
My fingertips caress the bobbing germs,
my fingers gliding deftly like swans
on pools of blinding amber-gold.

The rustle of the grass gently rippling
against my intrusion
like the holy sound of distant rolling sea
searing the skies with its voice of ancient brine

resounding some deep gong-like connection that
triggers an echo convulsing in me . . . taking me
way back, BACK.

Through my short time on this earth
to my parochial birth and my ties
to Mother Earth's mystical clay,
shaped through that bubble and boil and trouble
of primordial soup
to spit out my loan of suitflesh,
the frame which folds in this very soul,
I must return it to Her
one day,
on that fateful morn, which comes unadorned.

Memories . . . memories come screaming back.
A white owl shoots across the burning field of bronze
to alight and hoot its poems on yonder branch,
and the Grasshopper Bard of Summer
with his bowler hat and pipe
sits triumphant on his sea-throne of endless grass blades
groaning softly under his weight,
resting after having sung seven choruses straight,
his only audience the summer breeze,
and an abandoned barn door's wheeze
ascends a lilting cacophony
unrolled by his Orthopteran brother choir.
Off in the distance
faint puffs of train smoke.

A roan horse grazes lazily,
munching, chewing,
as its soft mane ripples in the gentle breeze
in time with the wind's
twinkling motes on the ocean's waves and crests
of the lush green sward which rolls out
in all its green plushness upon the hills.

Beauty is shifting.
Beauty is ephemeral,
unframeable,
heart-breaking in its evasiveness,
unable to be caught by space
and only caught by fragments of time.
Our cobweb nets of memory
allow us to catch the beauty of life
in a glance,
a mere instant
caught by us,
the observers
sent to witness,
sent to laugh,
sent to rage and rant,
sent to cry,
sent to love,
and sent to die.

Trust me, dear reader.
Remember those moments
and cherish them dearly.

They are the only true treasures
that you can ever keep
and take with you
on your endless quest.

Remember the summer
and the smell of her cotton dress,
the laughter of the child
running across the field
with pure and utter glee
as fireworks whistle and bark
through the screaming cobalt-blue sky behind.
Remember the joy as you whoop and scream,
hurtling down the road 100 km/h
with the radio turned up full-blast.

Ahh, blessed cocoon of youth!
Why did I wish to become wise?
Why did I want to learn everything?
The more you learn,
the more frightened you become
at all the destruction of which the universe is capable,
at all the stupidity and inanity of our endless fratricide,
consistent throughout history,
unrelenting in its toll.
I mull with dread
upon *all* the wickedness that can be unlocked
from the hearts of Man
and spread onto its hapless victims
like a vicious virus.

We're all fighting over ownership down here,
but nothing in this life can be fully owned.
It can only be borrowed.
The power and wealth that we all fight for
are like grains of sand sifting through our diamond gloves,
and like the taste of ash on the tongue,
possession is an elusive shield held up against life's
 impermanence,
and death is a living testament to its fleetingness.

If you'll excuse me, dear reader,
let me escape just for now just for a minute.

Let me reminisce
and bring back the summer,
the summer of old,
when innocence still reigned over my heart
and optimism still ran through my veins
triumphant in its unknowingness.

Let me bring back the memories of
when I lay gazing up at the summer clouds
that went racing along a perfect azure sky
like Spartan marshmallow battleships,
when I lay in my warm bed at night
snug as a bug in a rug
with just my toes peeking out for a fresh bite of air,
my eyes wild and sparkly
in the full mirth of my blossoming youth,
my eyes barely visible just above the covers
as my mother told sweet stories and lullabies

and even sweeter lies,
and when hope
sang exuberantly through my blood
like liquid gold
screaming through the caverns of my heart.

What is the cost of attaining adulthood?
We somehow manage to lose touch with that self,
that stranger-self who we were, way back then
when the leaves sang with dew on Saturday morn
and robins cackled gaily in their nibbly nests,
back then when we had time to notice
this and a thousand other things.
Look back through time, sweet angel,
and come back home unto yourself.
You might lose yourself somewhere along the way
through this swirling, snarling, mad world,
but you can always come back to *yourself*—your final destination.
Some believe that God made Man in his own image,
but on that the jury is still out to lunch.

One thing's for sure,
we all construct our own vision of the world
fashioned to our own image of it.
Maybe the world only exists in our heads,
but the world is your oyster.
Go on and open it.
And the mind is your playground.
Go on and conquer it.
Your time on Earth is yours.
Claim it, and if anyone ever attempts to take it from

you, fight for it to the bitter end.
Find your place in the world
and don't forget to shine
Shine, beautiful brethren!
Shine bright and blazing in your own brilliance.

Angel at My Doorstep

She took hold of my head
in her healing palms
to still
all the fire-pinball chaos
of ideas
and stabbing fears
and reassertions of logic
deflated and defeated by doubt,
all in raging conflict
all bouncing around
up there
like Pandorean atoms.
She whispered
in my ear, stooping and eager,
that . . .

Life
is only sad
when
you want it to be.
I knew
right there and then

in that very
instant
that my search was now over
and my life
once again
reborn.

Buddha Dawn

The early morning rose of dawn
bequeathed the jeweled sky
at night's end,
sends forth its courier bells
and diamonds clutched in shells

Showering down upon us
a great new hew of hope
and longing . . .

And through the streams
he will laugh with glee
and soaring birds
with bugles a-blaring
and peacock angels
condemned to ever ride
painted skies
and soothing winds
clutching forever to triumph the air
but never to speak
and the river
drowning itself

on its slow gurgle and murmur
with its soft sands
tumbling and turning
and digging and lifting.

And an owl turns and flees the scene
while the hawk awaits to see what
from the first rays of dawn
he may glean.

As the first rays crest the hill
and punch the conquered darkness,
there is a hush and a sigh,
a leap and a fly
as the sun,
all draped in dripping gold,
will triumph the day
and leave the shadows of yesterday
in mourning.

Disode to Tokyo

Oh, come, Tokyo,
take me to your heaving breast.
Here I am, swallow me up
and chew me good,
as I will surely do to thee.
But make sure to spit me out,
or I will split thee from belly to chin
and feel no clinging sting of sin,
just like Jonah would have done
had God planted a knife on him
and sent him on a suicide mission
into the slow gaping mouth of the whale,
and then I will expose thee
and all thy entrails to the world.
I will side with their plight
and reveal their fright,
dig deep and down into their buried
almost forgotten loves of yesteryear and yestergone,
in all their dank and sunken-eye despair.

I offer thee this chance
to come and lay down your power,
as the screeching of the tortured is
getting louder and louder by the hour and hour.

Come, lay down your power,
surrender your madness,
you howling, cavorting, mad capitalistic
free-falling beast,
you who need us
for your heaving, coughing heart.
Upon ripe and young gullible dreams you feast and feast
with fed fangs of fury
and fists of chemicals and dusts.
Tokyo, oh, Tokyo!
Yet somehow so endeared to my heart!
Save thyself,
for now is the hour
in which the bravery of Man truly begins.
Come, now, embrace thy rebirth!

Living with Radiation

(for the people of Tohoku)

Nuclear nincompoops
and class-A bureaucrims,
answer me this!

Do I have to take my Geiger counter
with me every goddamn time
I go to the supermarket
just because you won't do your job?

Will you continue to take
my hard-earned tax money
without batting an eyelid
just to keep your rotten ship afloat?

Will my kids
have to wear radioactive suits
from now on
every time they want to throw the frisbee in the park?

Will you keep building
your towers of catastrophe
even though
there are more fault lines
at your feet
than brain cells
in your head?

Will you continue to build
houses that glow
with contaminated cement?

Will you continue to use words like 'unexpected'
instead of words like
'incompetent' and 'arrogant foolishness'?

Will you continue to falsify labels
and underpay your workers
who risk life and death every day
to clean up *your* mess?

Will you continue to do
last-minute shopping for car batteries
with an impending apocalypse
back at work?

Will you continue to keep your leaders
out of their jailhouse nests
where they should surely come home to roost
and where they most certainly belong?

What will you do?
What *will* you do?
What will YOU do
to fix this mess?

Is Daiichi nothing more than
Chernobyl's black-sheep child?
A child that you have bound
head and foot
and locked up in your attic
when a journalist visits your home?

Amid an invisible rain
that tears at the sky's fabric
with the sound of ten thousand screaming banshees,
you send out your gypsy lackeys
to clamber over Daiichi's fraying corpse
placing bandages and stents
into your Frankenstein disasterpiece,
its cracked skull
still spewing out
your invisible legions of death,
waiting . . . pleading . . .
for your kind dagger
to come and give it its coup-de-grace kiss
of sweet stiletto,
or a proper burial for the whole village,
whichever comes first.
You are like the witch doctor
who won't perform the final spell!

All you do is mutter
'unexpected', 'unexpected',
but all I think is
'incompetent', 'dangerously incompetent'.

You leave your child
exposed like a pirate's bleached ribs
stranded on Neptune's forgotten shores.
Are you encouraging an exodus
of Daiichi crabmen?
Who will attack your capitol with wings?
With the chill silence of death?
Who will threaten your people? (no comment)
Who will poison your kids' lunches?
With first harvest goodies? (still no comment)
Who will threaten your coffers? (Man wakes up suddenly and
 shoots out of his armchair)
Oh, *now* I have your attention?
Is this some experiment in population control?
Don't you have enough blue-suited crabmen
ensconced in your offices already? Well?

Oh, but look at the time!
I have no more to waste
on your appalling silence!
It's beddy-byes, Mr. Strontium.
Let's shut this window to the world.
Tonight
there's something in the air.
Leave all your worries
in the rainy-day dustbins

of tomorrow.
Lie down
on your soft, creamy-white, swan's down quilt.
Never fear.
There's no bogeyman in your closet,
only one locked up
behind the doors of your conscience,
which needs not concern you!
Close your eyes,
close your eyes.
Dream tonight,
dream,
dream of all
the compensation claims
you can cut to shreds
with your monstrous garden shears
and hence save yourself
from the howling crowds
outside your door.

Ward Z

(for William Carlos Williams)

Damn this biological decline!
Damn this old frame!
Damn these crippled legs!

The love of my life
walks past my hospital window:
passing . . . going . . .
(trembling hand raised toward the window) . . . gone.
Her eyes, fixed ahead,
never turn.

Pillow catches trembling neck
as it falls.
Sighs tumble
uselessly,
unheard
by the deaf white walls.

Eyes turn
to the bedside table
where the flowers
used to sing—
and sing for me!—
every morning.

Death is near,
but Cupid's rusty arrow shard still aches.
If I close my eyes,
maybe—just maybe—
I might see her
smile again.

Winter Tree

Bleak
black
tree
of winter,
shining
with its skin
of congealed sap,
haunting bare horizons and
overcast skies.

Rattling
like a sack
of bones
in the wind.
Ominous,
like a giant witch's hand
shot out
straight from the earth,
suggesting
a long-forgotten curse.

Wrapped up in its mantle

of birch
and bark
but stripped
of its green summer garb,
deep within the halls
of its woody heart,
a single
solitary
thought
stands firm—
spring, Spring, SPRING!

Oh Savory,
Reckless Abandon

Beware of Hades' gliding ghouls
raging on the hoary wings of winter,
but behold the mighty mustachioed cherubim
riding on the chrome wings of triumph and rescue.
Far below is bald fuddy-duddy.
He points his finger at the first person he sees,
with white, terrible eyeballs
ascending and climbing into the forehead,
screaming out, *It's all your fault!*
brandishing his pipe
in the ever-enclosing night.
He stalks off to sulk and sigh,
but by and by
come charging the hollow young devils
in his stead,
full of passion in their hearts
and conviction in their tread.
They laugh and holler in the holy night,
raging and spewing
with stupid but almighty fountains of youth,
for youth's false gleam of eternity

leads them by the hand,
down and down
to the valley of vice and delicious sin
where they will break themselves
and be broken again and again
with no afterthoughts of hospitals,
kids,
or nursing homes.

Deserter

(for Gregory Corso)

Part I

Their cause is silent; their cause is powerful.
Their cause is obedience; their cause is control.
Their cause is intoxicating, bewitching, deceiving.

Last night I was summoned by a voice—
the voice of my conscience
dragged out of bed in the middle of the night.
He proceeded to berate, to scorn and vilify
all that I had held to be inevitable
in a world full of chains.

With a razor-sharp scythe smiling by his side,
he then warned me
of the ignoble option of ignorance,
the opiate blindfolds of voluntary distance
and industriousness which shut out the horror hordes
of the world's streets,
of the putrid stench of fresh-born money
crinkling between blood-fed fingertips.

Part II

My cause is romantic, my cause is loyal,
my cause is adamant, my cause is true.

Last night I refound a little boy
washed up on the lost golden shores of eternity,
who dreamed of a world of decency,
who longed for a world of brotherhood,
who wept for a world
on the brink of nuclear disaster and devastating sorrow.

That boy with the dunce dreamer's cap
moaning in the corner was me.

So call me a deserter.
Call me a dreamer.
Call me what you will.
But remember there is
nothing shameful,
nothing craven,
about the act of desertion,
when you've been conscripted
into an army
marching
towards oblivion.

Modern Stench

The offices at midnight shudder and wonder
where all the human heat has gone.

The sisters of Hades flutter and settle
back home to roost,
as the tin-man junky lays about,
wondering how to get his next boost.

The autumn winds course over the hills,
conquer the crest,
hurdle down into the valley,
plunging headlong into the river
and carrying through to the ridge,
where they shower the sky
with their vaporous ramblings.

In the distance the *gallahs* scream,
the clowns cry,
the politicians sweat over invested money
and dirty bets and patient beers,

the prima donnas croon,
the pimps squeak, the leeches scrounge,
and the hacks talk and talk and talk.

The gravy boat dribbles on the expensive cloth,
the coin and the trickle of the blessed donor
dropping a coin into the street cup.

The millionaire laughing with evil delight on his $1M yacht,
the genius pleading into the night
This is all I've got, all I've got.
Come now, sweet elixir of sleep;
take me to my cot.

Life Resurging

(An Ode to Jack Kerouac)

\mathcal{B}

Some people think
that happiness is a mountain of gold
just over the shoulder of the next hill
or buried under the rubble rainbow.
Some people think it's a magical destination
they're trying to reach,
but for those who just stare ahead
on autopilot,
the scenery outside slides and slides
as life glides past and gently by . . .

And they don't realize until it's too late
that they had all their priorities wrong.
But now the last train is long gone;
they're resigned to their fates,
consumed with self-hate,
waiting for blessings to fall into their lap.
But your hair is growing thin,
your resolve losing its grip,
your skin losing its shine,

and your sacrifice and devotion long forgotten,
swept up under a carefree carpet
that nobody notices, except their feet.
Your bargaining chips all crumble;
every yes is now a mumble.

What have you got to show
for all the time you put in?
For all the effort you surrendered?
For all the words you forced yourself
to squeeze from your lips?
Hollow and bare . . .
stripped of all meaning or rhyme,
suspended in time, given up to the ether
without a wisp of second thought or investment.

Meaningless train-track employment mantra—
but then you saw through it, then you knew it,
in that single descending tidal-wave,
crushing, joyous, and momentous moment!

Life flew back to you.
Like a fish crossing a stream,
like a sparrow findings its branch legs,
like the exulting man
screaming raw liberty from his lungs,
in the creases of her smile,
in the innocent jailed man's cry,
in the flowers nodding in the afternoon breeze,
and the misfits hurling and whirling

and shuttling down the highway with glee
and the fish jumping,
the trumpeter blazing!

The delicious, naughty excitement you feel
after curfew hours have long come and long gone,
your brain racing,
at the bewitching power,
the overpowering tumultuous silence,
at the witching hour—
welcome back, life.

Then it's there . . . in front of you . . .
a dripping white comet delight,
celebrating in the jade dewdrop of twilight,
as the doors to the forest
unclick and unlock.

Delilah of the Sands

(for Michael McClure)

With eyes of spinning anemones,
her desire dwells deep,
deep and dormant,
like a befanged angel
prowling the murky depths
of an ancient, porcelain river
deceivingly serene up above,
running right back
through the rubble of time,
as the joker spins the carousel
of that wheel we call history,
back to the Eden we lost
and never knew.
Locked up behind
its invincible gates,
Heaven and Earth
hath known
no fury
like a bawling fruit-peddling God
who hath been spurned.

We always reap
what our ancestors sow.
Are *we* always
to be blamed
for what *they* did?
Or for what we didn't know?

The itch to fuse, unite, become one—
the exact *opposite*
of the Divider's most unholy design.
How can *that* be called sin?

NO! Sin this be not,
fellow truthseeker,
this feeling that is so *right*.
Faith can be something admirable,
but it will not stand
up against the onslaught of *Reason*,
says Voltaire, peeking from behind a curtain,
and reason was a precious holy boon,
shat upon our brains
from above,
by the Holy Dove,
programmed *into* us
to smash the unreasonableness
and complacency of upstart faith,
trying to upstage the truth,
starting to stagnate the soul,
and leaving it there to rot
like useless jungle machinery.

If sin meant 'beauty'
in another language,
would it still play with your head?
Would you still lose sleep over it?
Much has been lost
in translation
between the devil
and the deep blue sea
and the words that rained down
from the sky.

We are all just beggars
down here,
scrounging for a few scraps
of fading truth

I Dream of Arson

(for Allen Ginsberg)

By day they have me chained to a desk,
suckling at the teat of a doomed system.
Code red: broken autopilot.
How do you stop this thing?

My dreams have been abandoned,
left to rot in the wings
like an old fading patient
forgotten in some dusty hospital corridor.

When I come home,
I feel drained and mentally raped.
My mind is wrapped up and preoccupied
in endless tasks and to-do lists.
When will they ever leave me alone?

By night
as I lay me down to dream,
I am lost in a mist of glorious rebellion.
I drag their ideologies and beliefs from their beds
and slaughter them in the streets

and burn their institutions
to the ground,
as I
stand cackling
with stupid rage,
in a voice
I don't know,
and with trembling hands
I stare at
but cannot stop.

Pride

Pride, oh, pride,
why do you have to be so proud and loud?
Why do you have to be so thick and relentless?

Behold the King of BS,
the ultimate builder, creator, and supporter of stubborn
 defence!

What do you have to say for yourself?
Have you ever been on trial
or in a state of denial?

Why do you flare up and hit the truth?
You get on your high horse
and cause common sense
to refute and rot.
You're better off sticking with your own lot.

What is it?
What do you have against us?

Speak now
or forever hold your curse!
If you can't be reasonable now,
it's going to be much worse.

Can we ever shake you?
Will evolution ever desert you?
No, certainly not!

For you have managed to slip into the minds
of rich men and mentors,
feeding them bare sustenance
and having them begging for more.

So I see you have found
your eternal seat.
You give warmth to the bosom
and spring in the feet.
You electrify the system
and muddle the brain.
You claim to keep us
from going insane

But I hope you're happy,
I hope you're convinced,
that your battles are won—
when you stir, all will flinch.

You custodian of family ties,
you choose the shape in which we die.
You knife us when we want to run and hide,

and you make up our minds
when it's impossible for us to decide.

You router of logic,
you destroyer of reason,
you pillar of stupid Samsonite strength,
you're accused of mind treason in the first degree!

But don't worry; needless to say,
I'll let you go now—begone! Be on your way.
Like an eel slithering from my fingers
you can go now; here,
you're forbidden forevermore to linger.

But, oh, I know you'll rust and wane
and turn your name
over into the other called Shame.
At least this time we're granted the luxury
to feel and cherish our reclaimed modesty.

While you stand there temporarily frozen,
licking your wounds,
we stand there and wonder when,
just when,
you'll be unbanished.
Oh too soon, too soon!

Diatribe of the Mind

I

Begone, rose-cheeked cherubim!

Do not haunt me with your holiness.
Let's raise them a toast from coast to coast.
Drain your cups, lads; we'd better be going.

In a devilish dance of despair—
in a moment of naked truth too true it's unfair—
while these devilish moments plod and plod,
we are only truly safe
under the wings of God.

Pouncing on your crutches of far-flung mayhem,
fly fast and furious,
east of windward,
and come into your kingdom.

Rest! What a luscious lie.
Truth on a cushion placed up so high,
to die and die and die again,
for love and love's sake only.

Like a letter in the post,
with a terrifying black spot,
you're pinned in on the course.
Yet you lie to yourself,
No, I'm not. No, I'm not.

Head high and hand held to breast,
faith and fate will take care of the rest.
Lo and behold! Over yonder bellowing clouds
methinks me saw me future wrapped up in a shroud.
So take heed and take hostage of your eyes,
which belie—witnessing a rare moment.

For while you plan and prepare,
adversaries are ever creeping up forward and onward.
Your fading courage of yesteryear,
now barely a murmur.
So rally the cry and spare the cur!

Oft I've been told,
in those stories of gold,
of aching leprechauns stretching
a yarn or two a tale,
of fame-bloated and dreary-eyed and myths swollen
of heroes rising and villains justifying.

Only shafts of light
have no need of truthful words of conviction.
For they've already been plucked ripe
from my lips.
Stay your hand and your merry man.
Complications—you can't afford them.

Cast luscious lust aside.
C'mon, condemn it between hollow breath!
Your fortunes can only burn and rot and tumble
from your so-called impregnable towers and spires and temples.
As nature creeps up on us,
with its invisible claws to pounce,
it comes to regain what's rightfully hers.
No, she won't budge an inch.

II

Like an open saucer ready to receive,
you come to me,
and twelve bright and blazing candles
hewed and hacked the ink of darkness.

Begone, mischief; come to make spoil of the night!
Begone, paranoid twin; come to besmirch hope
and smear it with fright.
Come, comely maiden; let us frolic, dance, and rejoice.
Reconnect your soul with its lips and voice.
Come unto what's rightfully yours,
and like the brazen midnight skylark
soar and soar!

MAT KONDO

Coming around the final bend,
you hear crowns of surf pound and roar,
as gentle pillows of golden sand
lay out cushions for the water to land,
free for the nonce from the moon's vicious leash.
Let me gaze upon these stars, I beseech, I beseech,
as boiling, screaming rock
pumped fresh from Earth's broken yoke
slithers and seethes rolling to the ocean in a sweet kiss of heat,
while the patient boughs and leaves of the defiant oak
push slowly onward to share the spires of the sky canopy
of tongues and time they defy and defy.

While the waltzing sands of the warm desert
leap from dune to dune
and ride freely under the blank gaze of the moon,
snow assails the mountain peaks
with a steady, silent thud,
while dying beasts clutch for eternity,
succumbing to the mud.

While 'rational' creatures labour for love of gold,
their appreciation of the all-surrounding beauty
is gradually losing hold.
As the listless torpor of the grey modern skyscape
is dubbed anew,
hold firm! Follow not the flock,
for yonder ship is coming into dock!

III

Spectre of the dawn,
come to deposit dream tax in the eye,
invisible worm of fear slowing, stealing,
with his claws of electrifying chills,
the pallor of despicable deceit
other propagandee's breath,
which has stolen the crown of the embodied spirit,
of the printed letter,
come to turn down the shade
and bewitch the twitching eye,
disturbed and restless,
that the truth has slipped through the nets of the mind.
The paralyzing spells of Sunday night's gloom
come to rob the triumphant light
of freedom's reign newly risen and begun Friday's night!

The thrub and drub of the morning train
raps its knuckles over the obedient sleepers,
like a mad, persistent xylophonist
trying to drum you awake
and sway you to sleep.
And up above all the din and the noise
your heart sinks, as you are propelled
into yet another day of insipid offices
and meaningless tasks—
all for the obsessive love of the dollar,
to send its burning effigy higher and higher.

Descending from the city to the plain,
fresh air, full smiles and genuineness do regain,
but over there in the corner,
or stuck up on some billboard by the way,
is the phoniness of modern society,
trying to spread and claw its way back.
So turn off the telly and turn off your minds to ads.
It ain't all lies, just shades of truth
with props and fads, making you sad
and greedy and anxious and bewildered
and alienated and deflated and frustrated,
leaving your dreams red and bloody,
hanging up by the hook dripping,
and left screaming for more.

For more what? Information?
Bah humbug! We're being drowned in it!
For more useless consumption
that generation upon generation has gone without,
as you scramble your jets
and search for all the pages not fit to print?

So stay in the system just long enough.
Then get out
before you fall under the sway
of its narcoleptic modern complacency,
and its brainwashing clout,
where victims are just figures and stats,
in a vicious unnamed war,
both worthy and unworthy
depending on which side you were on

when the battle lines were drawn,

drawn before you were born,

or being drawn without letting you know they were being
 drawn.

The unselected pieces of truth

hum and sob and wait under piles of dust neglected,

while the selected are pushed into the limelight.

But at a distance,

folded far back on the TV screen for the bloodthirsty,

you can jump on the bandwagon,

but first talk to the crew.

They just might be getting more out of it than you do.

So keep fast track;

traverse your private paths of joy,

for a new day will certainly come.

Look ahead, lads—land ahoy!

Paean to Romero

Murdered at mass
by the keepers of falsity and greed,
slaughtered by the army
for his outspoken honest creed,
baptized in sincere sympathy
for his brother and sister humans,
for his dying people,
could he turn no blind eye
while giving his sermon?
To grisly sights would he testify,
but one thing bothers me still,
and it still seems so scandalous—
while the Salvadorans mourned,
the foreign press couldn't seem to care less.
But wait a minute!
He's on the wrong side!
He's not one of those *thugs* or *scabs*
to whom we give supplies,
and while we buried him in soil,
we also buried the truth
with shovels of cowardice,
all the smear, propaganda, and malice.

How long shall it go on?
So if you find it in your heart
to stop and think this March 24,
think for Archbishop Romero
and what a true martyr really dies for.

He didn't die for any celestial nor fleshy reward.
He didn't die for any book or for any sword.
He didn't die for self-righteousness.
He died for having the guts
to confront too many ugly truths
that we were either
too afraid, ignorant, or indifferent to speak up for.

Rest in peace, Oscar.
But allow me to resurrect your fading cry
and your broken banner
from the dust of voluntary amnesia.

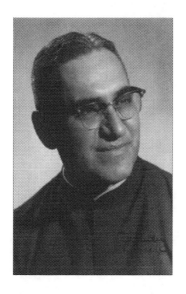

Spirit Indomitable

My head rolls to the dice of chaos
but sometimes,
just sometimes,
it spits out diamonds.

These diamonds,
whatever they may be,
and in whatever form they may take,
have proved
time and time again
to be my sole saving grace,
without which
the husk of my patchwork interior
would fall away
like the slough of dead snakeskin,
In a winter wind.

Every occasion we are confronted with grief,
or are able to summon the courage
to stand and face it
on our own two feet,

ALONE BEFORE THE UNIVERSE,
is an opportunity to claim something new
and get reborn.

These new parts are what I call
courage, determination and solid will.
Old parts of us crumble away like clay
and a new essence springs to life
from somewhere inexplicably within.
With the full momentum
of a raging phoenix
in its cloak of golden ashes,
with this new suit of armour,
we are able to adapt
and move on.
Our former selves
are left to flit
through the halls of yesterday.
like abandoned and dispossessed ghosts.

I Will, I Will

My people,
I will try to be there for you,
if not in person
then at least in spirit.
And I call on *all poetmen,*
those willing, those able to join me,
in a deafening chorus.
Hear me! Oh heed
the unbugled call!
Unleash those words
that sit warm and waiting on your tongue
like snapping hounds,
dying to speak for mankind.
Rest assured
that I am with ye all the way,
my people,
right to the very end.
I will defend ye
with the final puff of my lungs,
the final smite of my sword,
the final fist of my mind,

the final barb of my tongue.
I will defend ye,
I will, I will.

I will be your sniper,
deep upon the tower of the last standing defence of Man,
when the hordes of Hell
have been unleashed to feast
upon all that is forsaken and profane upon this flame-wracked
 earth.
If it be up to me
to hold them at bay,
then I will, I will.

I will be there at the foot of the scaffolding
when another innocent man falls,
and I will not forget the look of horror in his eyes
as his life is cut tragically short
by ignorance,
by gluttonous bloodthirst
for justice,
any justice,
even a blatant abortion of justice.
I will be the first to cut him down
and give him a proper burial,
I will, I will.

I will stand up in your union halls
to resound those grievances
that haunt your mind in circles

like the taunting of vultures,
grievances begging to be vocalized
on behalf of all.
Even if the room reeks of curses,
frosty looks,
and leather maces with steel-tipped studs
sharper than an alligator's spine,
even as the ogreous thugs approach,
I will hold my ground for you—
I will, I will.

I will be there
when your strongest convictions
and your Rock of Gibraltar philosophies
are attacked by the thought police of tomorrow,
and when your staunchest friends
decide to turn their backs
and flee like a flock of cravens
to the comforting arms of their unbelief.
If you need me to be near
to lend a sympathetic ear,
rest assured, my friend,
I will, I will.

When the tide comes lapping at your feet and all the odds from
 the warehouse of the Fortune Gods
seem stacked against you,
in that gap of time in which all decision dangles,
when a red herring voice slips in its sinewy poison,
into the white silence of your mind,

saying *all* is lost!
All is gone!

But hearken! Listen!
A voice . . . yet another . . .
golden . . . gleaming . . . true.
Listen to its pulse
as it fills the sails of your heart.
Listen to its determination;
listen to it say,
No matter what
I will hold.
I will, I will.

The Big Con

To believe in God who condones violence
is both misanthropic and counterintuitive.
Why would God, if she is truly the Creator,
sit back and watch Mankind
proceed to destroy HER work of art?—
an artform created in *her own* beloved likeness?
If you accept this to be true,
then you also recognize God to be a
Grand Vandal Extraordinaire of his own work!

The alternative and more plausible explanation
is that a power struggle is in progress,
between the forces of light and dark.
The claim of his 'Supreme Almightiness'
is then exposed as the Big Con that it is,
and that's why she needs our 'votes'
on election day,
against the evil forces scourging the universe.

I am not here to preach you an alternative.
The only sermon I can give is this:
Arm yourselves with the facts;
arm yourselves with the facts;
seek truth born of *Reason*,
NOT of bequeathed ambiguity,
for these are the arms
that you should *always* have the right to bear.

What Does It All Mean?

(Written after a visit to the Tokyo exhibit of the Book of the Dead)

A wise man came to me
in a dream
with words to soothe my fears
and fodder to feed my thoughts.

His words stick to my ear-memory
like a prairie burr
and sear their way
forever into my mind
like a crackling cattle brand.

He said,
Remember, son,
the soul of living things
is the very same
Soul-Essence
of the Universe!

With his words yet fresh
and shuddering with wisdom
in my slow-dying memory of the dream,
my mind conjured up a picture of the universe
as one incomprehensibly big and untamable millwheel,
a whirring dynamo
to which we are all fatally attached,
every hair, muscle, and sinew its prisoner.

This immediately erased my fear,
the fear of the black blanket of Death
that stalks the halls of the damned like a panting hyena,
and whose whisper and name haunts us all
in our future unrevealed days
like a cold wind wraith
lying in ambush around a brick corner with its smoky tendrils,
with foggy flashes of stony graves,
covered in lime and ferns
and ants having magnificent picnics on our bone-bed quilts.

The Fear of Death grips the spine
like electric chilblains.
Memories of who we were are
lost to float among the woodchips and flotsam of time
and the tumescent flow of space.

But *fear not!*
Everything is interlocked, intertwined, interhidden
somehow.
But the *grand* meaning of it all has been *shut out,*
lost, inaccessible.

In another dream the wise man said,
Life means whatever you wish it to mean.
Feel for the meaning. See the meaning. Create the meaning
from your vision within yourself where another universe resides.
All you have to do is dive into the river.
You are all architects of life!
Realize this!
And rise to your destiny which is your rightful throne and
your ultimate port of call!

Remember that if *our* soul dies
when we render up our body-clay frame,
then part of the *universe* must die too,
for the survival of the universe
hangs upon the imagination of creatures like us,
possessed of sparkling minds and radiant consciousness,
whose number continues to grow.
And if the number of enlightened souls is increasing,
perhaps that's why
the universe is expanding!

When we die,
our body dies with it,
our meat loan runs out,
but a voice, a signature, a strain . . .
carries on.

The real mystery is
where does the stuff of souls come from?
And don't give me no chemical formula!
You and I both know

that after 100 million years Man is *still* clutching at straws
as to what it all means.

Love?
Could it be love?
Love is self-generating.
Hate is self-destroying.
Oh, Love,
how I have learned
to dread thee!
When will you fix
my burned and shriveled wings?
Love continues to sustain you,
but *only for as long as you can outrun it.*

Let us remember
that life,
begun before birth,
back when we were all just tiny seeds
in the mass bosom of the cosmos,
carries on through death
into the halls of remembrance
and glorious oblivion.

And like a star,
which has waited millions of light years
to dance its diamond smile
for just one glorious moment in our eyes,
we too
will *not* be
forgotten!

First Harvest is the culmination of ten years of work, presenting verses that were madly scribbled down in cafes during lunch breaks, from the flashing windows of commuter trains, or while walking the streets of Tokyo at midnight.

In this, his first collection of poetry, poet Mat Kondo offers us a peek into the mind of a man deeply in love with the world and equally troubled by the existing state of affairs. Using his radical new style—neo-beat, influenced by poets ranging from Gregory Corso to the romantic poetry of Shelley to Japanese haiku poets such as Basho—he highlights the current 'de-progress of the spirit' propagated by the pursuit of greed. Each poem presents a sketch of the day-to-day sadness, despair, and ultimate beauty of mankind in the twenty-first century—a species at a crossroads.

The Antidote

Harbingers of deception,
the word virus *spreads*
like rabid carrier pigeons.

But there is an antidote.
Poetry,
betrothed to truth,
can deliver seeds
of great exploding beauty
and illumination.

All you have to do
is breathe deep,
polish your eyes,
and let your mind roam.

Mat Kondo is a Tokyo-based poet born in Toowoomba, Australia. His love and interest in poetry began in his twenties after being greatly inspired by the poems of Alfred Lord Tennyson and Charles Baudelaire. Kondo is a translator of Japanese to English, but his main calling is poetry. *First Harvest* is his first book of verse.

PARTRIDGE
A Penguin Random House Company

ISBN 978-1-4828-9626-8
90000

9 781482 896268